A Sleepless Eye

MIDDLE EAST LITERATURE IN TRANSLATION

Michael Beard *and* Adnan Haydar, *Series Editors*

A Sleepless Eye

Aphorisms from the Sahara

Ibrahim al-Koni

Selected by Hartmut Fähndrich

Translated from the Arabic by Roger Allen

Syracuse University Press

For a listing of books published and distributed by Syracuse University
Press, visit www.SyracuseUniversityPress.syr.edu.

ISBN: 978-0-8156-1034-2 (cloth) 978-0-8156-5279-3 (e-book)

Library of Congress Cataloging-in-Publication Data

Available from publisher upon request.

Born in 1948, **Ibrahim al-Koni** is a Libyan writer of Tuareg origins. After graduating from the Gorky Institute of Comparative Literature in Moscow, he served as a cultural diplomat in both Russia and Poland before taking up residence in Switzerland where he continues to live. A prolific author of works of fiction in Arabic, his second language, al-Koni is widely recognized today as one of the Arabic-speaking world's most original voices in fiction.

Hartmut Fähndrich, after obtaining a doctoral degree at the University of California, Los Angeles, has taught Arabic studies at universities in Switzerland. He is a prolific translator of works of modern Arabic literature into German and worked closely with Ibrahim al-Koni on the selection of aphorisms that make up the current collection.

Alain Sèbe is a French photographer who specializes in the photography of desert regions. His concern with that environment served as a major impetus in the publication of the German and French editions of this collection of aphorisms in the 1990s. A website devoted to his artistry (along with that of his son, Berny, who teaches French at the University of Birmingham in England) can be found at: www.alainsebeimages.com/english/index_en.html.

Roger Allen retired in June 2011 from his position as Professor of Arabic and Comparative Literature at the University of Pennsylvania. The author of a number of studies on Arabic literature, both pre-modern and modern, Allen is also the translator of a large number of fictional works by modern Arab authors, including Naguib Mahfouz, Jabra Ibrahim Jabra, `Abd al-Rahman Munif, and, most recently, Ben Salim Himmich, whose novel, *A Muslim Suicide* (Syracuse University Press, 2011) was awarded the 2012 Saif Ghabash Banipal Prize for translation from Arabic.

Contents

Foreword

THIS COLLECTION of aphorisms traces its origins back well over a decade to one of the final projects initiated by a group of European specialists in modern Arabic literature (amongst whom I was privileged to be included). They had come together in the context of a European-funded project entitled *"Mémoires de la Méditerranée"* (Memoirs of the Mediterranean), aimed at presenting to a Western reading public examples of autobiographies and memoirs penned by contemporary Arab authors.

In this particular case, Hartmut Fähndrich, the German translator, was able to take advantage of the close proximity of the Libyan writer, Ibrāhīm al-Koni (as he prefers to transliterate his name), who, like Fähndrich, now resides in Switzerland. Together they chose a selection culled from al-Koni's recently published collections of aphorisms, focusing in particular on those that were concerned with the environment. The French photographer, Alain Sèbe, who specializes in photographs of desert landscapes, offered to finance the publication of the aphorisms and to include some of his superb photographs in the published books. Fähndrich's German version, *Schlafloses Auge*, and Yves

Gonzalez-Quijano's French version, *Un oeil qui jamais ne se ferme*, both appeared in 2001.

I undertook an English translation of the selection at the same time, but was unable to find a press that was willing to take on the publication, even though Alain Sèbe had agreed to finance the collection's appearance in as many languages as possible. Since then, of course, al-Koni's reputation has been gradually growing among Western readers (although—one might say, typically—the Anglophone readership has been the last to respond to the trend), and, as I write these words [November 2012], Libya certainly remains the focus of a good deal of attention. It is for these reasons that I am extremely grateful to Mary Selden Evans and Syracuse University Press for agreeing to bring al-Koni's desert wisdom to the attention of a reading public that certainly could use a clearer understanding of the historical and cultural background against which contemporary and transforming events continue to take place in Libya and elsewhere in the region that we term the "Middle East." That al-Koni should also be so powerfully concerned about the environment in which humans live and which is demonstrating to us on an almost daily basis the perils involved in its ongoing abuse is yet another factor that renders this collection of considerable importance.

In conclusion I would like to express my thanks to the two anonymous reviewers of this manuscript who made some excellent suggestions concerning details of translation.

ROGER ALLEN
Philadelphia, November 2012

A Sleepless Eye

Nature

الـــــطبيعة

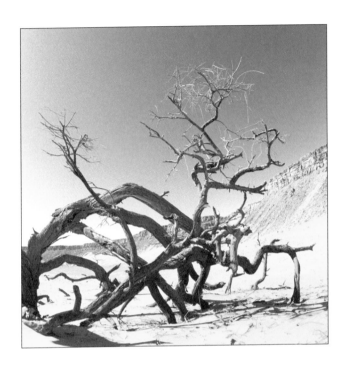

Nature, a sleepless eye.

Nature, the demon inside the bottle.

Nature, a mother who observes our mischief, yet pardons all our faults.

Nature is a sage, and to anger a sage is dangerous.

To ravish Nature is to provoke the demon inside the bottle.

Nature does not beget the wicked.

Nature begets us as innocents; the world makes us wicked.

By iniquity we betray Nature.

Nature—body of the unseen; the unseen—spirit of Nature.

There are no means to cross the barrier between seen and unseen.

The seen is the trunk, the unseen the root.

In the unseen we live; in the seen we die.

Nature—that hand by which the unseen grasps us.

Nature's hand also affords us the unseen.

Nothingness is in conflict with the world but has a pact with Nature.

Nature is by instinct a hermit.

Every corner of Nature is God's own house.

Nature—God's house, one we defile instead of worshiping therein.

Godhead: Nature in the heavens; Nature: godhead on earth.

The godhead is Nature in the unseen; Nature is a godhead on earth.

The roots of compassion lie in Nature; those of mercy in God's heaven.

Evil has no power over one whose heart has become a friend of Nature.

Nature may move slowly, but it does not forget.

For God's creatures Nature is homeland and knowledge is exile.

Nature is fully capable of discovering the means to help it recreate itself.

Nature is in eternal conflict with reason.

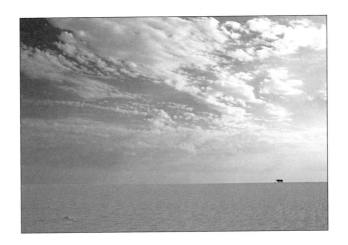

Nature grants species victory over the individual; reason grants the individual victory over Nature. Hence the conflict of reason and Nature.

Nature is anger; mankind is revenge.

Nature will never escape the evil of mankind unless that miracle occurs whereby mankind's greed is finally staunched.

Nature—our own sacred house, daily despised.

Mankind shuns Nature, the giver of life, preferring the company of mankind, the bringer of death.

You can commit your affairs to Nature, but beware of doing so to mankind.

Nature snatches by force those paltry oblations that we refuse to offer it.

Nature gives life because it also gives death.

Nature only kills us to give us life. The world only gives us life to kill us.

We kill Nature's body, forgetting that Nature's body is our own.

We only really die when Nature dies within us.

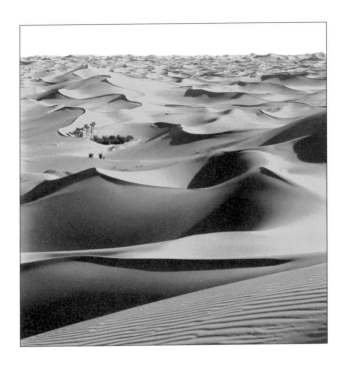

Through our death in Nature we live; through Nature's death in us we die.

When we die by Nature's hand, we also live. When we die by mankind's hand, we die.

Death at Nature's hand is life; life by mankind's law is death.

Nature brings life; knowledge death.

Only those who seek refuge in Nature will escape its retaliation.

Nature never gives itself to an artist who does not give himself to it.

Estrangement from Nature is the secret cause of illness.

Estrangement from Nature—wilderness; separation from the world—birth.

The world chastises anyone who fails to amuse himself; Nature chastises anyone who does so.

When we are frivolous, our destination is the world; when we shed the ability to indulge in frivolity, that destination becomes Nature.

Worldly people are convinced that passion is something established by the law of Nature. Chaste people are convinced that passion is totally alien to the law of Nature.

Nature's fault is that unblemished gain should fall into the hands of the corrupt heir.

If we learned how to listen properly to the sound of Nature, we would not be so mistaken about our own interests.

Nature's requital is always just.

Nature's cruelty towards us is only to teach us a lesson.

Nature teaches us to look inside ourselves, but warns us not to become too introverted.

Nature only turns in on itself in order to lose its own Nature.

Nature refuses to acknowledge its mistakes since its errors are final and irredeemable.

We travel the sea to quench our thirst for Nature.

From within Nature itself we fashion chains with which to throttle it.

Nature is in conflict with the powerful.

In Nature's law the indigent are loyal soldiers.

Exclusive authority is Nature's law.

Rejection, Nature's religion.

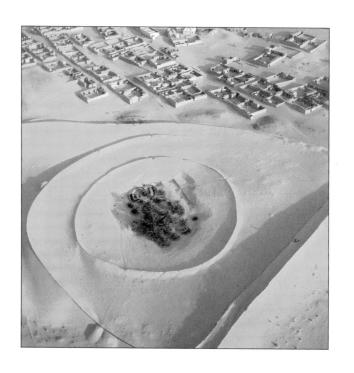

The oasis plays with the death sentence that Nature pronounced on it thousands of years ago; in Nature's reckoning thousands of years are but the twinkle of an eye.

On the day when humans declared war on Nature, execration enveloped humanity.

We are obsessed with our bodies for fear of deadly disease, and to the same extent commit the basest evils against Nature, forgetting that it is our most important body.

Nature will remain exposed to mankind's greed as long as mankind is convinced that Nature was only created for it to despoil.

The most essential things are those for which we do not pay a price (water, air, fire, and earth).

Nature does not give itself to us if we do not give ourselves to it.

We give ourselves to people, and they shun us. But when we give ourselves to Nature, it gives us its very self.

By adhering to Nature we nourish our roots. By adhering to people we consume our souls.

Deity—Nature in the unseen. Nature—deity in the seen.

Nature's beauty is beauty even though we deem it ugly. Ornament's beauty is ugly even though we deem it beautiful.

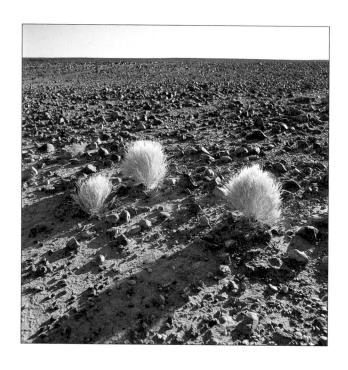

On earth man corrupts and Nature creates.

When man creates, he copies Nature. When Nature creates, it copies itself.

Nature is the Creator's trustee over his creation.

We only see wind in dry grass,
We only see wind in sand gusts,
We only see wind in the angry Sea,
All because visible Nature is a seer, one that responds not to the seen, but to the unseen.

Intuition: the spirit's prophecy; Nature's prophecy: the body's intuition.

The body—memory in Nature; memory—Nature in the spirit.

The more the spirit thirsts for knowledge, the more the body thirsts for Nature.

The creative person is both lover and beloved of Nature.

Nature grasps us by the body in order to enliven the spirit within us.

In birth Nature becomes food for us; in death we in turn become food for Nature.

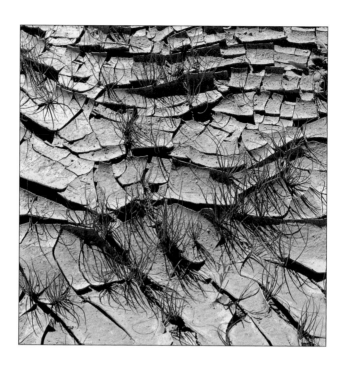

Nature, a cat that eats its own children to protect them from an evil ghoul named the world.

It is not enough for us to love the Creator in Nature. We must love Nature in the Creator.

Seasons

الـفـصـول

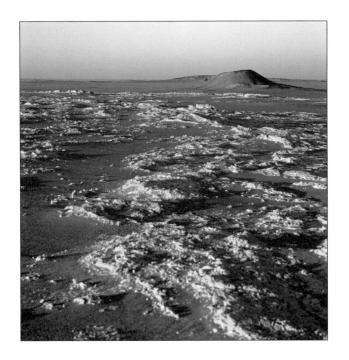

The leaves of trees are sheets of paper on which the Seasons record their prophecies.

With wind the autumn strips bare. With snow the winter veils.

Trees cannot don winter clothing unless they have been stripped of their autumnal attire.

Autumn tears the clothes off the bodies of trees and forces them to sleep in winter's embrace.

Autumn is not a rival of winter; rather autumn is a maid who prepares a chamber in the garden for her master, winter.

In winter's eye no tree becomes a virgin unless it has been stripped of veils.

With the autumn wind comes rain to help to blow leaves away.

Winter is a sanctuary that trees may only enter naked.

A useful companion is one who veils the nakedness of trees in snow shrouds.

Winter refuses to receive mankind in its sanctuary naked, yet it will only accept trees stripped bare.

Desert

الصحراء

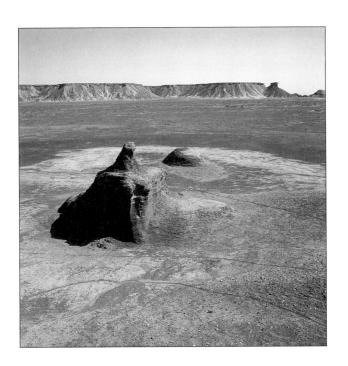

The Desert, God's homeland.

Exile is like the Desert, a homeland for God.

The Desert, oasis of eternity.

The Desert, homeland for the spirit, exile for the body.

The sky, Desert above; the Desert, sky below.

The Desert, magic bottle of freedom.

The Desert, a house with walls of nothingness.

How miserable a child for whom the Desert is a homeland, unable to enjoy life in his homeland or to live far from it.

He who has the Desert as homeland has nothingness as a house.

Desert's beauty is metaphysical.

Desert is the wakening of the spirit.

Were not the Desert paradise lost for the body, it would not be paradise on earth for the spirit.

Desert, a home in touch with eternity.

Desert's space, the walls of eternity.

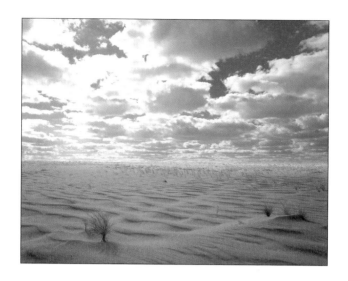

Desert is like the sea, a Desert in its unseen dimension, but not in its manifest one.

Desert with wells underneath is earth; Desert in its lost dimension is Desert.

Desert in its extension over space is expanse; Desert in its unknown dimension is Desert.

Desert is a sea with wilderness as its trunk and eternity as its root.

Desert is in conflict with existence but in harmony with its adversary, nothingness.

The Desert's enchantment is borrowed from that of eternity.

Desert is a paradise, not through water but freedom.

Desert is a paradise of nothingness.

If the Desert were not lacking water, freedom could not have become water for it.

The Desert's body is purified by the Desert sun; the Desert's spirit is purified by solitude.

The Desert's nakedness is borrowed from the sky's.

The Desert will never be hidden as long as the Desert's heavens are not.

Wasteland will remain the Desert's fate so long as it is still fate for the Desert's heavens.

We go to the Desert in order to quench our thirst for freedom.

In the Desert we die of thirst for water, yet we live by quenching our thirst for freedom.

In the Desert we die in body but live in spirit.

The Desert has never betrayed us. It is we who have betrayed the Desert.

Desert pays nothingness as a price for a felicity named freedom.

Lover of the Desert, prisoner of freedom.

Isn't the lover of the Desert the lover of eternity?

The world is body, the Desert spirit.

Did you say the Desert can kill through hunger? Yes indeed. When did the spirit ever provide bread?

The world kills us with its chaos; the Desert enlivens us with its tranquility.

Freedom is like the Desert: we only dwell in it in order to transcend it. We only transcend it in order to run back to it.

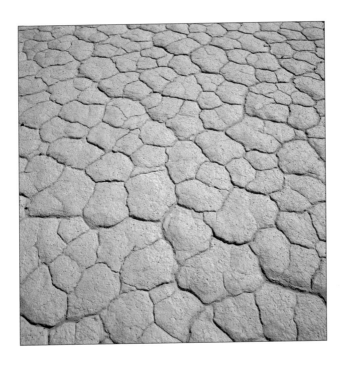

The Desert's devotee can choose to stay in the oasis, but the oasis's devotee may not decide to stay in the Desert. That is because the oasis is captivity whereas the Desert is salvation.

Desert, body of freedom; freedom, spirit of the Desert.

Desert, freedom incarnate; freedom, Desert concealed.

Water

الماء

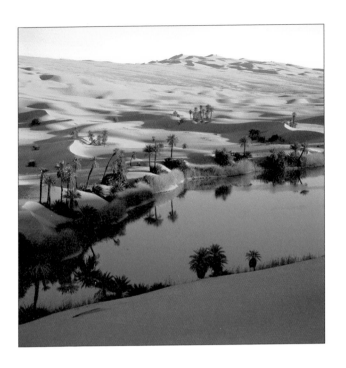

Water: a god whose strength is freedom.

Water, the heavens' life-giving sperm, planted in the earth's womb as life's embryo.

Water, a secret borrowed by the heavens from the earth in order to give it back as a sperm which from the earth's belly will produce a secret called life.

Water, guard of eternal life.

Water, a saint who dies in order to give life.

Water is a Phoenix, never dying, never destroyed. It dies on earth, then is reborn in the heavens. Severed from the heavens, it is then reborn on earth.

Water is a Phoenix destroyed by fire and reborn as ice.

Water is a virgin whose fate is to be exposed.

Through submission Water is weakened; through challenge it turns defiant.

How can Water not belong to the kingdom of heaven when it is an entity with no taste, color, or smell.

Water is time.

We are subjects of Water, but time is subject to us.

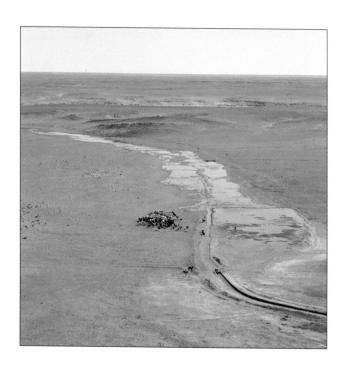

For this world Water is a companion; for eternity time is a companion.

Water is flowing time; time is evaporating Water.

Whenever Water decides to be rid of slavery's fetters, it longs to escape to the vast expanses of the heavens.

Water is an earthly entity. Wherever it abides, the world is close by. Wherever it goes, the world follows behind.

Water became an enemy of freedom on the day it became a disciple of the world.

Water is spirit for the body.

Water that plunges down the river is never wasted. The river takes a circular course that leads it across a land here to bathe in a Sea there. Thereafter it returns to its house by another route.

Spirit and Water are twin lovers, separating, uniting, and walking together.

Whoever sees Water gushing without doing anything to stop it is like the person who, seeing someone with a bleeding wound, does not rush to offer help.

Blood is the Water of mankind. Water is the blood of the earth.

In the presence of Water is the presence of creation. In the presence of creation is the absence of freedom.

For the tree of life Water is a trunk and spirit is a root.

Water is the noblest of all the things the world reveals.

River Waters quench the body's thirst; sea Waters quench the soul's.

Charity, like Water, is a delight, crushing everything barren.

At moments of insight Water is regal; at moments of anger it is a tyrant.

Water, nature's poetry; time, eternity's poetry.

Water, secret of the seen; time, secret of the unseen.

River Water, like body mass, is in a truss, strangled by its narrow banks. Sea Water, like the vastness of the spirit, lives free with no banks.

In Water's reflection lies the secret of children's love of Water.

Rain is a deity, taking back today what it gave yesterday.

Flood, an ephemeral river; river, an eternal flood.

Like river Water, truth never stands still. Is it because we too keep changing and never stay the same?

Water meanders on its course to avoid confrontation. If it hits something solid, it avoids the obstacle by changing course. If only humans would imitate Water, they could avoid the evils of conflict.

Water dies to give life.

We despise Water even though we realize that it is life.

Who are you, Water? Earthly treasure or heavenly secret?

Only Water can unite heaven and earth in marriage.

Water never weeps. It sings.

Water was born so that sacrifice could be part of its fate.

The miracle of Water lies in its ability to be liberated from the body.

Drought, Water's revenge through the law of renunciation. Flood, Water's revenge through the law of retaliation.

A cloudless sky must merit our approval whenever the matter is linked to weather, but it must face our disapproval whenever it is linked to life.

Water sings to console weeping creatures.

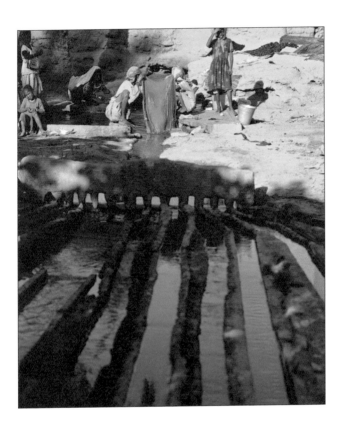

As young children thrive at their mother's hands, so does creation with Water.

Through loss of Water we lose our selves.

In God's kingdom Water is a ruler; in mankind's kingdom a slave.

Who are we? We are Water.

Spirit is enslaved by body, and body is enslaved by Water.

Water is only imprisoned in order to turn stagnant, putrefy and die.

Water goes to great lengths in making decisions. It moves from the exile of the seen to that of the unseen and from the exile of the unseen to that of the seen.

Water's alternation between the secret and the vacant is evidence of its love for lost freedom.

Water's lesson teaches: "Beware of all apparent weaklings!"

The secret of Water's power lies in its flexibility.

Water can never be overpowered because it is so fragile.

With torrents Water challenges; with brooks it shows compassion.

Water's fate is to give life to creatures and kill off fire.

Water is an enemy of fire because fire is an enemy of life.

Water kills fire in order to protect life from the ravages of fire.

The Water that kills fire also dies in that fire.

Water's homeland: land, sea, or the heavens above them.

Water in itself is freedom, but in its existence for people it is bondage.

The wanderer in the wilderness is one who has lost track of Water, not one who cannot find his way home.

For those in the wilderness Water is homeland; for those in thirst, homeland is a labyrinth.

Water, the only belly we enter to emerge alive.

We emerge from Water's belly alive, but the Water that enters our belly does not.

Bondage is only refreshed on Water's banks.

Like air, Water is despised until the day when it is no longer there.

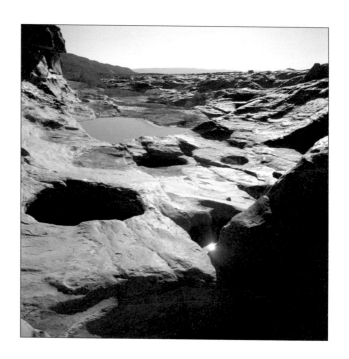

We have refused Water's munificence just as we have that of the agent of our existence.

The charm of rain is not that it can cleanse the heavens of dust and pollution, but rather that it can cleanse streets of pedestrians!

Rain empties streets of pedestrians so it can spend time with a passer-by who has come out to meet it alone.

Through Water we are alive.

Through Water the body lives; through freedom the spirit lives.

Water is the source and mirage the shadow.

Like God, rain loves those who love it, not fear it.

Rain, the bringer of leaves to trees in springtime, snatches them away in autumn.

Water is a social being because humans will never congregate in a land without Water.

Water promises people life, but it doesn't promise freedom.

Water, prophet of life, but not of freedom.

Water is spirit for the body; freedom is Water for the spirit.

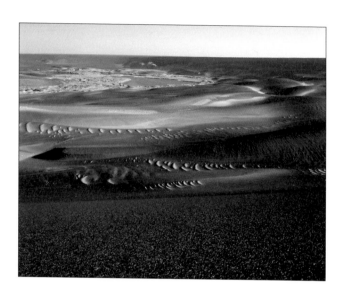

The body is Watered from the spring; the spirit is Watered from the sea.

In thirst we go to springs; in longing we go to the sea.

For the disciple of freedom, Water, like bread, is a snare.

Water gives us itself, so we can live by it. But when it is given to us by others, we lose our freedom.

Water brings people together; profit pulls them apart.

In affiliation to two clashing kingdoms—earth and sky— lies the secret of Water's ascendancy.

The earth is body; in it Water is spirit. The sky is spirit; in it Water is body.

Like mankind, Water dies on earth as mass and rises again as spirit in nothingness.

The occultation of the three eternal entities—water, snake, gold—only becomes a law in order to prove that the seen is merely ephemeral; it is the unseen that is eternal.

Sea

الـــبحر

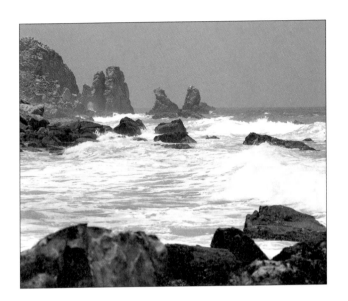

The Sea: water bereft of water.

The Sea, fount of eternity.

Land water, water of the world; Sea water, water of eternity.

But for the bitterness of Sea water, it would not belong to the kingdom of eternity.

The bitterness of Sea water is borrowed from the vessel of eternity.

Sea water on the tongue of eternity is saliva beloved by the Sea.

If Sea water were fresh, those who rode the Sea would not die of thirst.

Sea water was not created to be drunk, but rather to sing.

The Sea has become a haven for freedom because Sea water is not fit for drinking.

We dread the Sea because what we dread about it is eternity.

In the Sea's inundation lies the cure for bodily disease. In its lost dimension lies the cure for spiritual disease.

Eternity inhabits the lost dimension of the Sea.

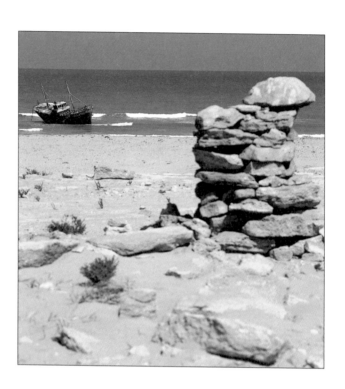

It is the lost dimension of the Sea that both enchants and scares us.

The song of the Sea: its threnody for its lost dimension.

The Sea entices us with water in order to give us freedom instead of Water.

It is not the Sea depths that scare us about the Sea; what scares us is the freedom that lurks there.

The feud between Sea and wind, a fight between lover and beloved.

The Sea only responds to the call of its beloved, the wind.

Does the Sea sing to remind us of its existence or ours?

The Sea's song, the world's elegy.

The Sea elegizes the world, but the world does not hear.

The Sea's elegy, strangers' gospel.

The Sea only talks to strangers.

The Sea is the close friend of strangers because it is a neighbor of eternity; and eternity is a homeland for strangers.

Sloughs give us flowers; the Seas produce sweet water.

But for the lost hollow in the Sea, it could not sustain the waters of all rivers.

If the Sea-floor were like other floors, it would be overflowing with river- and rain-water.

Children throw stones and clods into the Sea because of all mankind they are most aware of its lost dimension.

Do you want to know something about eternity? Then learn to listen to the song of the Sea.

We will never find a Sea in the Sea unless we seek its lost dimension.

The Sea is a sacred space that we befoul with trash. Then we have the nerve to resort to it for our food.

The Sea is a Desert with floods for its stem and the unseen for its root.

Like the Desert the Sea is eternity's neighbor.

Whoever loves the Sea will never be afraid of it. Whoever is not afraid of the Sea will never be possessed by it.

The Creator is like the Sea: we only confide in Him when we love Him; He only confides in us when we do in Him.

We resort to the Sea in yearning for freedom. We flee from the Sea in fear of freedom.

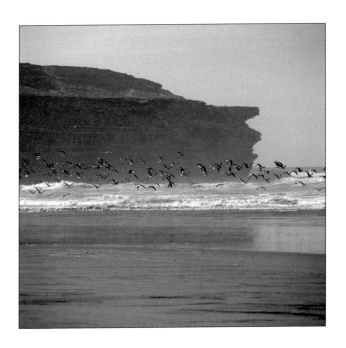

What secret is there in freedom that entices even the Sea?
What secret in freedom that alarms even the Sea?

The Sea protects those who seek protection; in that resides
its nobility.

The Sea only forsakes those who have doubts about it.

We have to court the Sea for a long time till we eventually
discover that freedom is the lost dimension in our beloved
Sea.

In spite of the Sea's generosity, its wealth is in water; thereby
proving that the world's richest person is the ascetic.

The Sea is never bothered by rain water or rivers because it
is an ascetic whose law is to give away all it receives.

The lover of the Sea has the freedom to land on an island,
but an island lover does not have the freedom to set out to
Sea; for islands are traps, whereas the Sea is freedom.

The Sea kills its lovers in order to revive them; it preserves
lovers of this world in order to kill them.

The world promises us more than it gives; the Sea gives us
more than it promises.

Whoever adores the Sea does not reveal his passion. The
Sea is a demon that never kills the people it hates, only
those it loves.

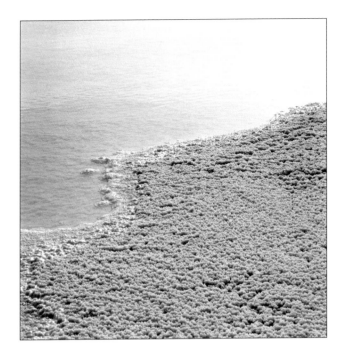

The Sea in flood is a swimming pool; through insight a vision.

The open Sea knows; it dreams; it inspires; it wrongs; but at the very last moment, it flinches.

Does the Sea's talk become a babble because the rivers that pour into it are spirits that only speak the dialects of their homelands?

Into a homeland called the Sea flows a time called river. The Sea never fills because it is a boundless place, and the river never stops because time's primary trait is eternity.

Sea and Desert

البحر والصحراء

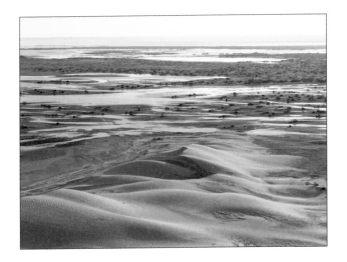

Desert and Sea: how alike opposites are!

Sea, water Desert; Desert, sand Sea.

Whoever crosses the Sea Desert dies of thirst, so does the crosser of the Desert Sea.

Like the Desert, the Sea is Sea through freedom, not through water.

The Desert revives through nothingness; the Sea kills through existence.

The dividing-line between Sea and Desert is an isthmus separating existence from nothingness.

The Sea only stays calm in order to spy on its beloved, the Desert.

The Sea addresses us in clamor; the Desert in silence.

Talismans drawn by the wind on the Desert's surface are the same as those it draws on the Sea.

Land hiding a prolific flood in its belly: Sea turned upside down. Sea hiding prolific sands in its belly: land turned upside down.

Everyone is a prisoner of his own exile: the Sea hides Desert in its belly, while the Desert hides Water.

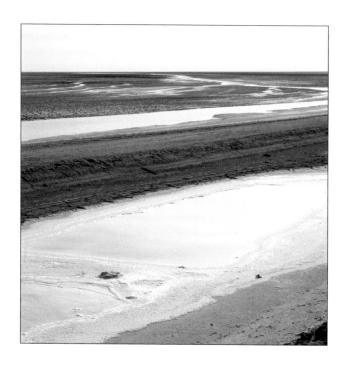

Wind, Desert's message to its beloved, the Sea; wind, Sea's message to its beloved, the Desert.

Desert hurls its sandy swords to the north in a desperate attempt to reach the shores of its beloved, the Sea. In its turn the Sea pushes wave upon wave to the south, yearning to reach the borders of its beloved, the Desert.

The Sea is associated with adjoining land, yet the land is not linked to the Sea, since land is country, whereas Sea is freedom.

For both land and Sea freedom is a shared arbiter of supreme importance.

Desert finds freedom in moving to the Sea. Sea finds freedom moving to the Desert. That is because both have long since realized that things only find freedom through their opposites.

The Sea's waves crash on the shore in quest of freedom. The Sea then retracts its waves for fear of freedom.

Every oasis is a trap; every Desert salvation; every island exile; every Sea freedom.

How can the Sea not strive in its desire to meet its beloved, the Desert? How can the Desert not similarly long to meet its beloved, the Sea? Neither of them embraces any religion save freedom.

The Sea, movement; the Desert, tranquility.

In the Sea's movement is the Desert's tranquility; in the Desert's tranquility is the Sea's movement.

Whoever cannot find Desert in the Sea will never find Desert in the Desert; whoever cannot find Sea in the Desert will never find Sea in the Sea.

Wind

الـريح

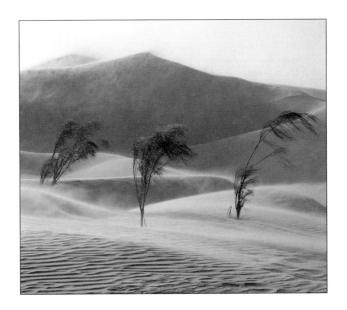

Wind, a master who reveals the unseen and hides the visible.

Wind, that invisible entity that makes things visible.

Wind was created to be a harbinger of seasons.

Wind was only created to make trees living creatures.

Wind, a talisman that creates others.

The Wind's secret are the talismans that it fashions on sandy surfaces or patches of water.

Wind is a messenger that never disobeys its instructions because the message it inscribes on the sand's surface is the same one it inscribes on the water's.

Autumn Wind tears the leaves off trees as an offering to the altar of eternity.

The Wind disapproves of leaves still hanging from treetops in autumn.

Through Wind trees return from exile; through wind also they go into exile.

Kudos to Wind that entices trees to sing, dance, and recite poetry.

Wind revives trees, but it cannot do the same with rock.

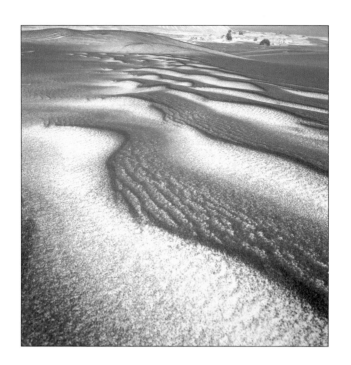

Wind comes forward to entice rock into revealing its secret, while rock slights the wind with songs of nostalgia.

Were transition not a law for Wind, it would hear its own secret in the insouciance of rock.

The sound of Wind in desert wastes is a lament. Yet when the juniper tree stands in its path, that sound is a song.

The Wind's mission: to render everything hidden visible, and everything visible hidden.

Wind never tires of offering us this counsel: "Only someone who has chosen death as destiny offers life a cause."

By adopting bodily form, Water is a demon; but, by refusing to do so, Wind is a god.

Wind is a god whose mission is to disclose the invisible and hide the visible.

Rock

الحجر

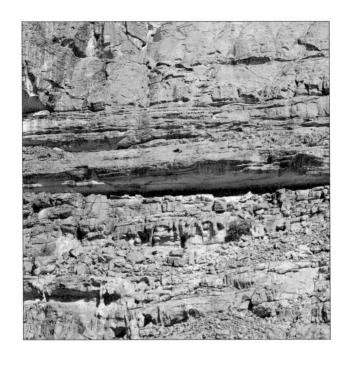

Rock, eternity's song.

Rock in nature, a living being; rock in perception, a dead being.

Rock, a mass suspended between existence and nothingness.

Like a god, Rock is an isolated substance.

Rock is an eternal entity since it has never lived as companion to spirit and body.

For eternity Rock is both lover and beloved.

Rock's mass is a symbol.

For Rock silence is a language; for humanity silence is reprisal.

People do not hear what Rock has to say because they are not used to silence.

The discourse of Rocks is prophecy.

In the silence of Rock prophets read a heavenly message.

Through its insouciance Rock can say things that the tongue muscle cannot manage.

Insouciance, Rock's language.

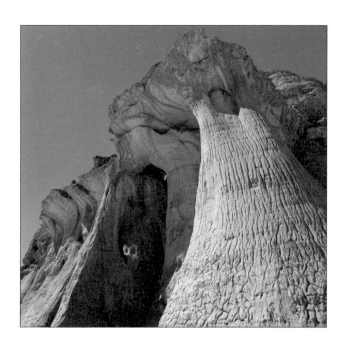

Through language humanity falls silent; through silence Rock speaks.

Rock relishes talking the language of water.

Only that which is born can die. Rock is not born.

Rock, a heedless entity.

Rock's law, reliance on neutrality.

Solid rock was the paper of the ancients. The first book in mankind's hands was Rock.

In the law of the ancients Rock was a holy book.

For the ancients Rock was a messenger bringing absolute certainty to generations, and so they worshipped the possessor of such certainty.

Only Rock can subdue the wind.

Rock refuses to live by any other law than its own.

If Rock did not live by its own law, it would never have become a god in the law of our forebears.

Rock has every right to boast since it is eternity's beloved.

Rock can pride itself on belonging to the kingdom of eternity.

I have never set eyes on Rock without its revealing to me through its mass the mark of eternity.

It is only when Rock encounters the wind that it sings of its sorrows.

Rocks speak, but humanity fails to hear.

The secret of Rock's authority lies in its conviction that it exists.

Inhabited by existence Rock inhabits the world.

Rock's distinction is that it does not monopolize existence, but through its own existence confirms the world's.

Rock, do even you have doubts about eternity?

For freedom Rock is a symbol.

Freedom, Rock's denomination.

Rock occupies a range within the desert domain, but through the spirit it inhabits eternity.

Rock inhabits a divide between the temporal and eternal.

From Rock the world only gets mass.

Rock's great wisdom lies in escaping the world's clutches.

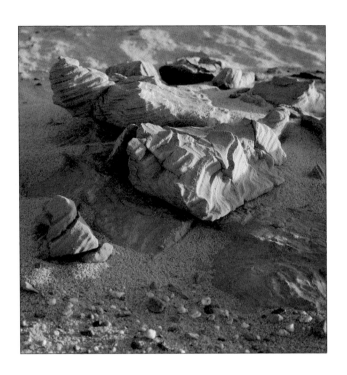

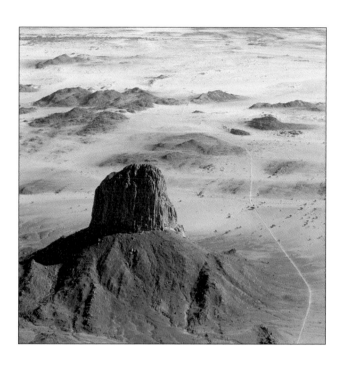

Rock is a boastful entity in that it exists with itself in eternal solitude.

By the law of the visible Rock is a dumb solid; by the law of the invisible Rock is an epic poem.

Rock's nobility lies in its insouciance; its wisdom in its silence.

Language is existence, but existence is also a language. Every entity speaks even though it may be a piece of solid Rock. Rock can speak as long as it crumbles.

Change is the discourse of unspeaking entities. Water, the discourse of ice boulders melting; dust, the speech of solid Rock crumbling.

Trees and Flowers

الشـــجرة والزهرة

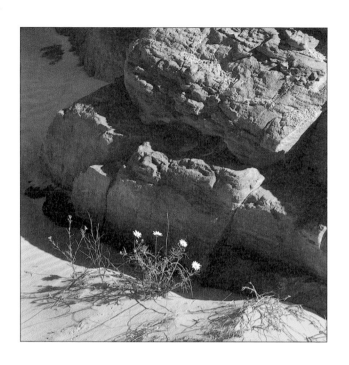

Trees would be another kind of being if the wind did not play with its leaves.

Trees only speak when the wind blows.

Without wind Trees are specters or upright pillars. When the wind blows, Trees turn into living creatures.

The autumn wind is not content to turn leaves of Trees into corpses. It scatters the leaves everywhere, not to make the victims an example but rather to prove that the injunction has been executed.

Trees stiffen to block the winds, so the winds wail.

In spring Trees recover what they have lost in autumn, but we do not.

The tree is a Phoenix that kills itself through autumn leaves, then resurrects itself through spring leaves.

Trees spill their blood in autumn leaves.

Autumn Trees are quickly stripped bare because they long to meet their beloved, eternity.

Can a Tree keep its name "tree" when autumn winds have stripped off its leaves?

Trees revive with the advent of spring, whereas we die in spite of its arrival.

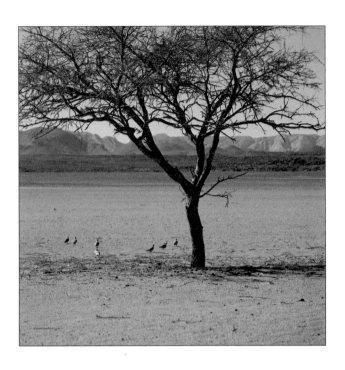

Autumn leaves fall victim to the arrows shot by autumn rain.

Wind plays with Trees in autumn till snow rushes in to rescue them.

In Treetops the color of old age is yellow.

The smell of fresh firewood, the perfume of a murdered Tree.

The rose that opens loses its perfume. Beauty that opens on to the visible loses its secret.

The very essence of Flowers is their declaration of the existence of lost Flowers.

In existence the Flower is creativity; in its perfume the Flower is a call.

Flowers address strangers with tidings of scents. Flowers address friends with prophecies of existence.

The existence of Flowers, prophecy. The scent of Flowers, good tidings.

The sayings of Flowers are clearer than those of humans. The perfume of Flowers is clearer than the sayings of Flowers.

Flowers, smiles of the unseen.

The Tree is a hero who never falls twice.

We can never possess the rose and at the same time keep it alive.

Treasure of the wicked: gold. Treasure of the sage: a rose.

Gold: treasure of the body. Rose: treasure of the spirit.

Gold: treasure of the seen, and so it disappears. Rose: treasure of the unseen, and so it is manifest.

Fire

النار

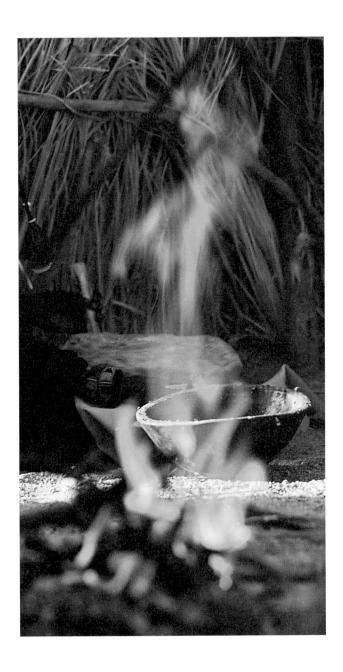

Fire is a snake that chases among the rocks a mouse called wind.

Fire is a lover of wind, but water's foe.

Humanity bows down to Fire, which in turn bows to air.

The wisdom of Fire lies in its bowing down to an unseen power.

Fire is a sage that does not believe in what is seen but what is unseen.

Air is Fire's watchman.

Fire neither kindles nor lives unless it has enough air.

Creatures are oblations to Fire, but Fire itself is an oblation to air.

Air: a condiment for Fire's food.

For creatures Fire is the chief tyrant, but in air's clutches it becomes a slave.

Fires never descend on countries uninhabited by winds.

Water is Fire's poison, and air its antidote.

For Fire air is food and water is poison.

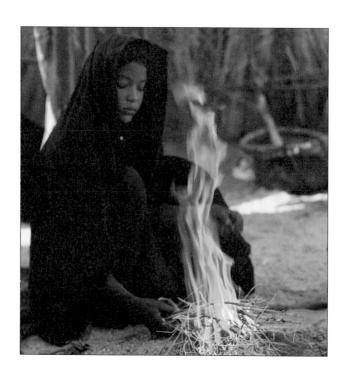

Fire's authority stems from that of the unseen power.

By Fire water gains freedom; by ice slavery.

Through Fire water is spirit; through ice, body.

Fire and water are eternal foes everywhere, but in the human body they are the closest of relatives.

That water and Fire harmonize in the human body is mankind's secret.

Freedom is Fire, but it is Fire that revives the Phoenix of the spirit.

Afterword

THE RANGE of literary genres within which Ibrahim al-Koni functions is a wide one, very wide. There are long novels in several volumes and collections of aphorisms (of which this book provides a sample), but also works of short fiction and even novellas, sometimes short, other times long.

However, whatever genre he invokes, al-Koni is always trying to achieve the same objective: to present his particular universe (or perhaps we should say, "his universes"). First of all there is the Sahara, and especially that part of it in Libya, even though borders (and particularly national borders) are hardly relevant in this context. The universe, as we rapidly come to realize when reading this author, also implies the cluster of relationships that link human beings to the world in which they live, that being their primary role in life. As a result, al-Koni's texts play on the complex registers of narration and signification.

The author also devotes the minutest attention to landscapes, their flora and fauna, imposing mountains alongside tiny grains of sand, dried up wells in the desert and valleys furrowed by streams in flood, the acacia tree offering a little shade against the beating sun, or perhaps a truffle poking

up through the earth's crust . . . The desert's inhabitants are also portrayed, their mode of living in this environment, and the connections they maintain with the various landscapes. Strong men are those who can blend themselves completely with the nature that surrounds them, while being conscious all the while of the particularity of their way of life; weaklings on the other hand are prevented by their unsated desires from living peaceably in the desert world. Al-Koni is equally interested in relationships between people and the social conduct of these nomads, be they shepherds or hunters, these men and women who belong to a tribal society with its still lively traditions.

Finally, there is another angle: the philosophical interpretation of everything that is presented, everything visible, audible, tangible, and palpable. For this author in fact, all these elements have their own profound import and belong to a similar universe. Needless to say, this is the aspect within which these aphorisms need to be considered, they being the last of the literary genres that this author has tackled. He has done so in a series of nine volumes published between 1998 and 2000. The aphorisms' author is at pains to bring out the latent meanings behind these visible phenomena, these multiple universes, in collected form. Aphorisms (the Arabic for which is *hikam*, the plural of *hikma*, a term linked to the notion of "wisdom") are an intrinsic part of the Arabic literary tradition. Examples exist from the pre-Islamic era, but the Qur'an itself has undoubtedly contributed to the popularity of this literary genre. We have important collections from the earliest days of the Islamic era, especially from the pens of mystics who

have always appreciated the value of concise formulations that promote reflection.

Al-Koni's aphorisms, as is the case with all his other works, rest on the conviction that everything in the world has its own place, role, and function, all residing in a network of connections and tissue of meanings. Water and rain join sky and earth to each other; stone and rock transmit their ancestors' heritage but are not expected to endure forever since "the eternal executioner" (al-Koni's term for the sun) will manage to bring things to a close, aided by wind and water. The latter may seem fragile and even lovable, but is actually pitiless; the former "veils" and "unveils," but sometimes that can require centuries. Fire sits between air and water: the first is its food, the second its poison.

The universe of these aphorisms is not solely that of the Tuareg world, but also belongs to that of mystical traditions, whether Muslim or Christian, with such authors as al-Niffari (10th century CE), Ibn al-`Arabi (d. 1240), or Angelus Silesius (d. 1677).

Many of the ideas, images, and observations expressed in these aphorisms also appear—sometimes word for word, at other times in a slightly different form—in al-Koni's narrative works. But here he chooses to isolate them from their context in order to present them for the reader's contemplation, in all their absolute significance. In spite of the obvious interest of this exercise, it is clearly not without its own risks, since an idea expressed by a character in a novel can convey a completely different notion within the new form.

This collection results from a selection made by the German translator. With the author's agreement, he has chosen

nature as its basic theme. A set of broad themes has been identified and treated in a more or less detailed fashion in accordance with the place such topics occupy in the original Arabic volumes.

The difficulties associated with the translation of this type of writing are obvious enough. The translator is constrained at times to sacrifice part of the text's rhythm in order to remain close to the original; elsewhere he will find himself confronted with pairs of terms, synonyms or antonyms, which have no equivalents in the target language. With the philosophical nature of these texts in mind, the decision has been made to give preference to the meanings of the original.

HARTMUT FÄHNDRICH

Sources

List of Photographs

Sources

Ibrahim al-Koni's Collections of Aphorisms

Abyāt [Verses], 2000.

Amthāl al-zamān [Aphorisms of Time], 1999.

Dīwān al-barr wa-al-bahr [Collection of Land and Sea], 1999.

Fī talab al-nāmūs al-mafqūd [In Quest of Lost Law], 1999.

Nazīf al-rūh [Bleeding Spirit], 2000.

Nusūs al-khalq [Creation Texts], 1999.

Sahrā'ī al-kubrā [My Major Sahara], 1998.

Wasāyā al-zamān [Testaments of Time], 1999.

Ibrahim al-Koni's Works in English Translation (2014)

The Animists. Translated by Elliott Colla. Cairo: American University in Cairo Press, 2012.

Anubis: a desert novel. Translated by William M. Hutchins. Cairo: American University in Cairo Press, 2005.

The Bleeding of the Stone. Translated by May Jayyusi and Christopher Tingley. New York: Interlink Books, 2002.

Gold Dust. Translated by Elliott Colla. Cairo: American University in Cairo Press, 2008.

The Puppet. Translated by William M. Hutchins. Syracuse: Syracuse University Press, 2010.

The Seven Veils of Seth. Translated by William M. Hutchins. Cairo: American University in Cairo Press, 2009.

Photographs

All photographs by Alain Sèbe unless otherwise indicated.

Nature

Seasons

Desert

Water

mN